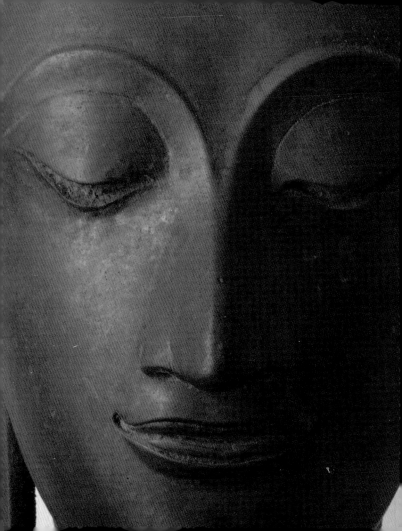

Thai Buddhas

Dawn F. Rooney

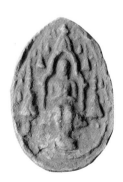

River Books

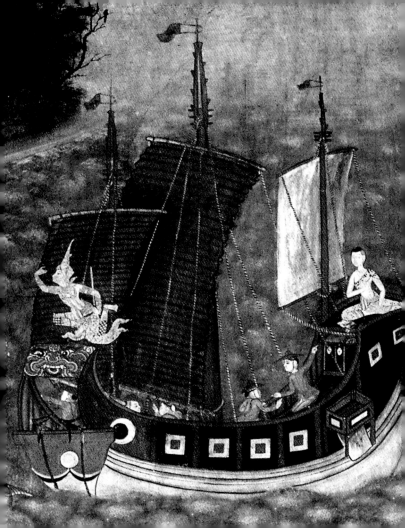

contents

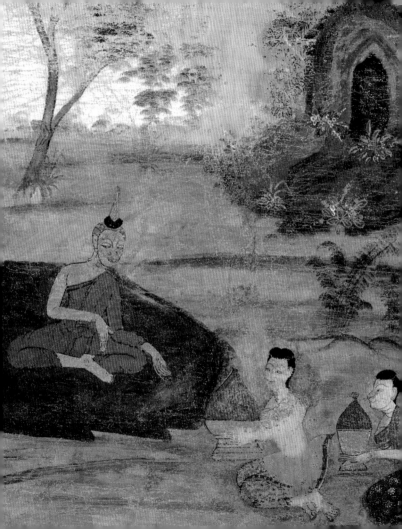

Millions of people throughout the world follow the teachings of the Buddha, which are as relevant today as they were twenty-five hundred years ago. Buddhism spread gradually from its origin in India through Asia by land and sea along several trade routes. In modern times, it travelled to the West where today it is a popular alternative religion to people who are searching for meaning and peace in their lives.

The story of the Buddha's life – from birth to enlightenment to death – is entwined with the scriptures based on his teachings and, together, they form the essence of the Buddhist tradition. The Buddha's doctrine was not written down in his lifetime and no single version of his life exists, but there is a common core of key events that are reiterated through images, narrative paintings, carvings and sculpture. The life of the Buddha and his teachings unfold on the pages of this book through the sacred art of Thailand, a country internationally renowned for its beautiful and creative interpretation of Buddhist art.

The sixth century BC in India was a period of political, social and religious upheaval. The prevailing religion, Brahmanism, was restricted to the priestly caste and the people resented this exclusivity. They were ready for religious reform and the Buddha, who had recently attained enlightenment and discovered the path to eternal peace, was ready to spread his message. I want 'to give light to those enshrouded in darkness,' said the Buddha. His approachable and compassionate manner readily drew followers and many joined his movement. After the Buddha died, disciples conveyed his teachings orally, but differences in interpretation eventually occurred, which resulted in the formation of various schools.

Theravada or 'School of the Elders' is a Hinayana sect that arose in the fourth century BC and adheres closely to the teachings of the Buddha. Two hundred years later it was transmitted from India to Sri Lanka and then gradually spread to mainland Southeast Asia, where it was firmly implanted by the beginning of the common era. Today Theravada Buddhism is practiced in the countries of Cambodia, Laos, Myanmar (Burma), Thailand and south Vietnam. The Mahayana or 'Great Vehicle' sect evolved slightly later than Theravada and differs mainly in the addition of bodhisattvas, compassionate beings who postpone their own attainment of Buddhahood to help others achieve enlightenment. This sect expanded north to China in the third century AD; then east to Korea, Japan, and north Vietnam. Vajrayana or 'Thunderbolt Vehicle' is a development of the Mahayana sect that became prominent in the seventh century AD. It supports an esoteric worship of Tantric

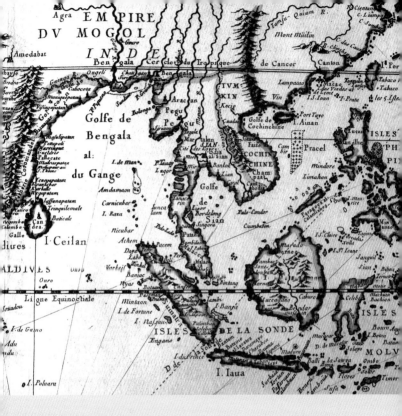

Buddhism and flourishes today in Nepal, Tibet, Mongolia and Bhutan.
As Buddhism travelled eastward its popularity in India declined and, by the
seventh century AD, it was eclipsed by an outgrowth of Brahmanism called
Hinduism, which is the prevailing religion in India today.

Different interpretations of the Buddha's teachings and the need for a code of conduct in the monastic community undoubtedly stimulated an awareness of the necessity for written versions.

The *Tripitaka* or 'Three Baskets,' compiled from oral sources in the first century BC, is the primary text for Theravada Buddhism. It is written in Pali, an ancient language of India derived from Sanskrit and is, therefore, known as the Pali Canon. The *Tripitaka* is divided into three parts or baskets under the headings of discipline, teaching or '*dharma*' and advanced teaching. Over forty volumes cover subjects such as the life of the Buddha, his discourses and the development and organization of the *Sangha* or 'community of Buddhist monks'.

Teakwood poles with lustrous ivory tips are latched together to form a table for holding a manuscript while studying it.

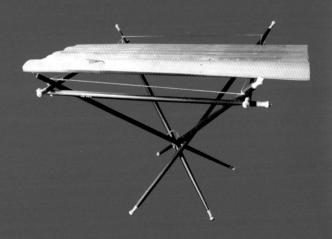

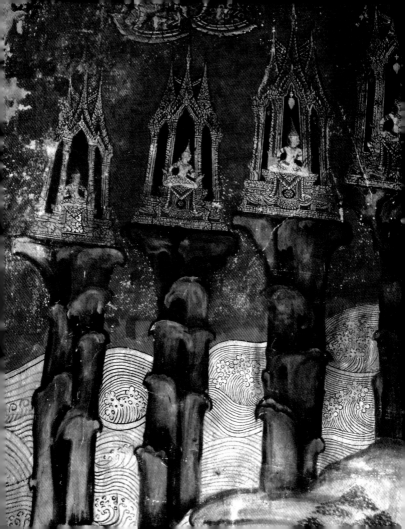

The *Traiphum* meaning 'Three Worlds' is a mid-fourteenth century treatise on the universe according to Buddhist cosmology. The contents centre on the three worlds or realms of existence of the universe, and their inhabitants. Elements of the *Traiphum* are represented symbolically in sacred Thai architecture and mural paintings.

Buddhist cosmology defines the universe as a continent divided into regions with Mount Meru, ruled by the god Indra, at the centre. Spheres of heavens spiral above and layers of hells descend below. Concentric chains of alternating mountains and oceans surround Meru and the Ocean of Infinity encloses the mass. The mythical Himavat forest, located below the heavens on the slope of Mount Meru and inhabited by wild animals and strange creatures, is a popular theme for Thai painting and the decorative arts.

According to Buddhist cosmology, all human beings pass through various lives in a continuous cycle of birth, death and rebirth, the ultimate goal being nirvana (literally 'blowing out') or enlightenment. In each lifetime, one accumulates *karma* meaning 'action' or conduct, the results of which have carried to the next life. One can be reborn as another person, a god, demon, ghost or animal. Bad *karma* is punished and good *karma* is rewarded, taking one further along the path towards nirvana.

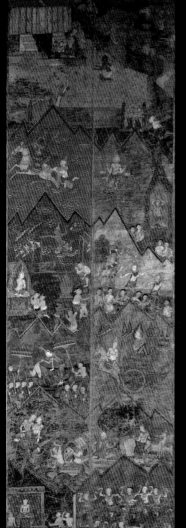

jatakas

Before Siddhartha Gotama attained enlightenment, he passed through many lives as a bodhisattva or a buddha-to-be. He was reborn in numerous human and animal forms and in each life he perfected a fundamental virtue and gained greater strength. Siddhartha's moral evolution in his previous lives is recalled in the *Jatakas* or 'birth stories,' a series of some 550 tales. Each one is placed in a historical setting and illustrates a virtue. According to legend, the Buddha used these stories to teach people the consequences of good over evil.

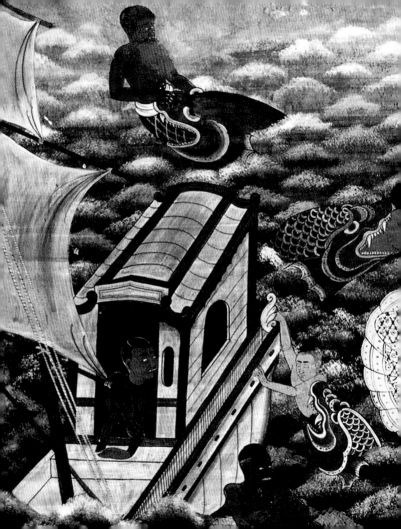

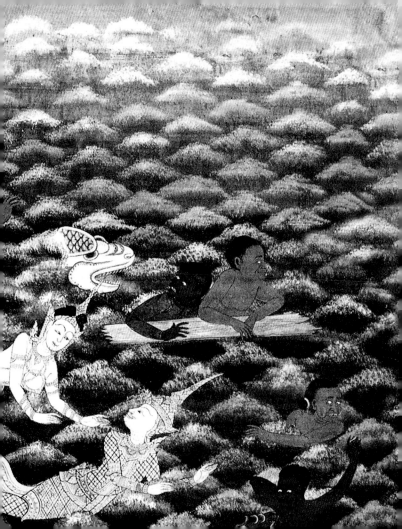

The last ten *Jatakas*, called the *Tosachat* meaning 'ten births' in Thai, are favourite themes in Buddhist literature and art and are depicted in a lively, spirited style in mural paintings on temple walls and woodcarvings and in Buddhist manuscripts. Morality is the dominant theme in this last set of *Jatakas*, which recall ten principal virtues or perfections that a bodhisattva must practice in order to attain enlightenment and to become a Buddha.

The story of Prince Vessantara, which expounds the virtue of generosity, is a well-known tale in Thailand and gives a sense of the style and mood of all the *Jatakas*. The bodhisattva is born into a royal family as Prince Vessantara. He marries Maddi, a princess, at the age of sixteen and they have two children. Life in the kingdom

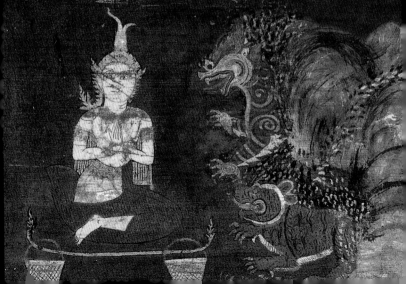

abounds with luxury and prosperity, which the people attribute to Vessantara's royal white elephant. The neighbouring kingdom does not possess such an auspicious animal and they recently suffered a devastating drought, so they ask Vessantara for the elephant. He complies. Then a torrential storm, followed by a severe drought, descends on his own kingdom. People blame this misfortune on the loss of the elephant and Vessantara and his family are exiled to the forest. En route, he gives the chariot away. In another encounter, he allows his children to become slaves for a poor family. And in a final gesture of supreme generosity he gives away his devoted wife. Vessantara's father eventually reunites the family and they return to the palace in a magnificent procession. Vessantara ascends the throne and is known ever after as a generous king.

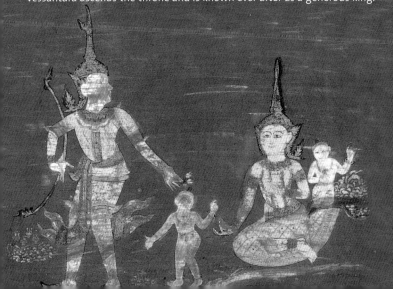

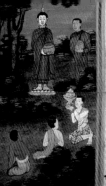

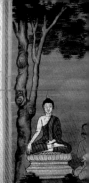

manuscripts

Suviving Thai manuscripts testify to a past tradition of highly skilled artisans. Palm leaf and folding manuscripts were handwritten in either Pali or Thai and some were lavishly illustrated with lively and vibrantly coloured narrative scenes. The paper and paints were made from natural pigments found in the fertile tropical forests of Thailand.

Palm leaf manuscripts were mainly Buddhist texts, such as the *Traiphum* and the *Jatakas*. Dried palm leaves were cut into thin, rectangular strips, which were incised with a sharp tool. Then a pigment made from soot and oils was mixed with water and applied to the surface of the leaf. The incisions absorbed the pigment and thus highlighted the writing. The leaves were then strung together to form a book. Important or particularly fine manuscripts were bound in decorated wooden covers inlaid with mother-of pearl or lacquered in black or red with gilt highlights

and a border. For further protection, the manuscipts was wrapped in a silk cloth. Another type, the folding paper book, was made from the thin, inner bark of a specific tree. Fibres were boiled to a paste-like consistency and spread on to a rectangular frame for drying to produce a stiff, natural coloured paper. The lettering was done with a bamboo quill and pen using black ink. The paper was folded back and forth like an accordion to form a book. Besides Buddhist themes, popurlar secular subjects included history, geography, folklore, literature and medical practices.

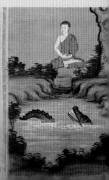

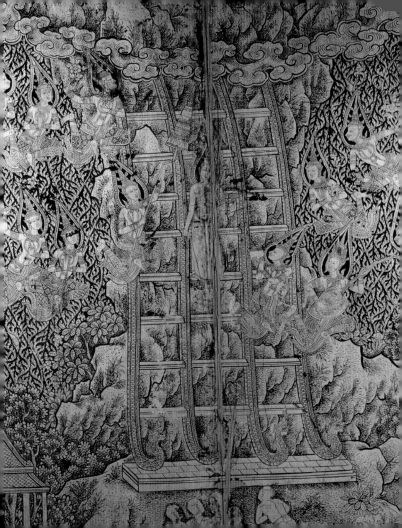

scripture cabinets

Cabinets specially designed for storing sacred palm-leaf manuscripts are a focal point in a Thai temple and were particularly popular in the eighteenth and nineteenth centuries. The teakwood cabinet is tall and wider at the base than the top so the sides have a sloping profile. The doors and sides are intricately decorated in black and gold lacquer with motifs inspired by Buddhist mythology and nature. The Buddha descending from Tavatimsa Heaven at the end of the rainy season after preaching to his mother is a favourite theme for decorating the doors of a scripture cabinet (left).

Several coats of black lacquer are applied to the wood and polished with charcoal to achieve a smooth surface. Using a paper pattern, the design is painstakingly punched onto the wood with a needle and dusted with chalk to make an imprint. The black areas are sealed off and thin sheets of gold leaf are applied. The cabinet rests on a wooden base with either plain or lion-shaped legs, a Chinese-inspired style.

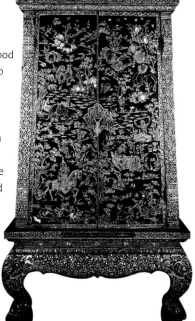

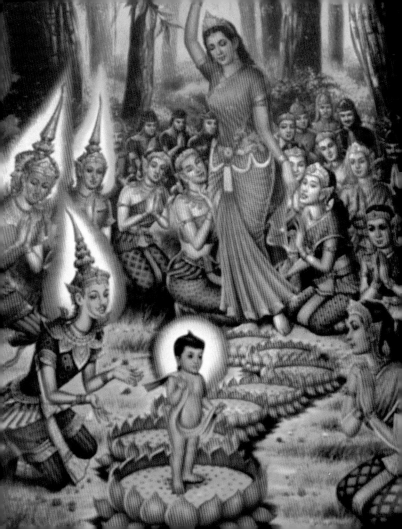

The Buddha's family is Hindu. His father is a warrior and ruler of the Sakya clan in the Ganges Valley at the foothills of the Himalayas in southern Nepal, near the border of India. His mother is a beautiful and intelligent woman named Maya meaning 'Illusion'. One night on the full moon of the summer solstice in the sixth century BC an immaculate conception takes place. Ten lunar months later, Maya, en route to visit her parents, stops to rest in the shade of the trees at Lumbini Grove. She senses that her time is near and stands, clutches a tree branch and a baby boy emerges from her side. The gods Brahma and Indra preside over the birth. 'Rejoice O queen! A mighty son has been born to you!' The newborn is named Siddhartha. His family name is Gotama and as a male in a royal family he has the title of 'Prince'. Sages examine the prince and identify thirty-two signs on Siddhartha's body that foretell he is destined for greatness and will be either a universal ruler or a spiritual leader. 'What a marvelous personage he is!' His mother dies seven days after the birth. During his childhood, Siddhartha's father gives him everything he desires and shelters him from unhappiness and suffering. Siddhartha is a handsome boy, a gifted student and skilled in warrior's arts. He marries a princess chosen by his father in an elaborate wedding ceremony at the age of sixteen. Some years later, she gives birth to a son.

Not a mother, not a father will do so much, nor any other relative;
a well-directed mind will do us a greater service.

(*Dhammapada*, Chapter III, Verse 43, translated from Pali by Irving Babbitt)

Despite having all the luxury he could desire, Siddhartha becomes increasingly dissatisfied with palace life and, after seeing the reality of human existence, he chooses to follow a different path for a more purposeful life. While riding in his chariot outside the palace, Siddhartha encounters four stages of life that he has never seen before. The first three – aging, illness and death – are signs of suffering. His fourth encounter is with an itinerant holy man who seems peaceful yet is without family, home or possessions. Siddhartha contemplates these four encounters and realizes that the sufferings of the first three men are inevitable in all humans. He vows to search for the cause of suffering and to find a way to transcend it. So he decides to leave his family, to 'Go Forth' and to join the way of the holy man. On the night of his twenty-ninth birthday, while the palace is fast asleep, he departs with his faithful groom and horse. They come to the bank of a river in the forest and stop to rest. Siddhartha renounces his worldly life in a ceremony presided over by the gods Brahma and Indra. He cuts his long black hair with his sword, removes his princely clothes and jewellery and puts on the simple robes of a monk. His remaining hair forms rows of tight curls and his ears are elongated from years of wearing jewellery – both distinguishing marks of a Buddha. He orders his groom to take his ornaments and horse and return to the palace. 'I am about to retire from the world,' says the Buddha.

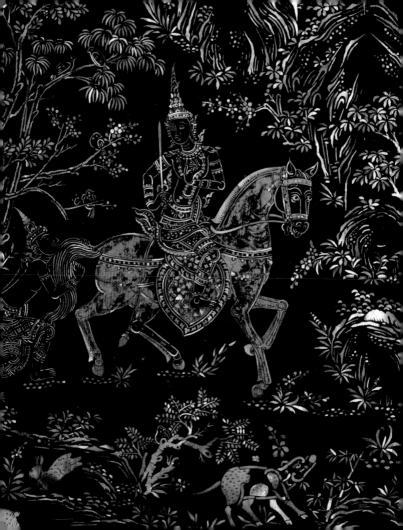

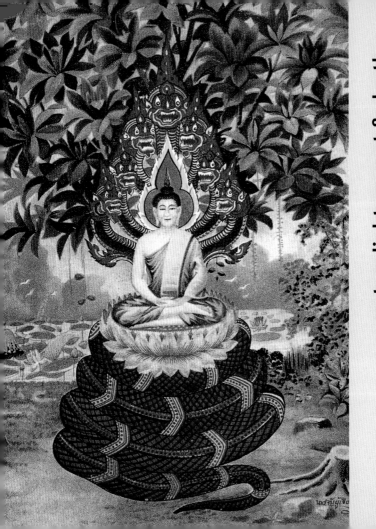

> *Forests are delightful; where the worldly find no delight, there*
> *the passionless will find delight, for they look not for pleasures.*
> (*Dhammapada*, Chapter VII, Verse 99, translated from Pali by Irving Babbitt)

For the next six years, Siddhartha the ascetic searches for the truth. He apprentices with teachers until he learns all they have to offer and he practices extreme austerities, including fasting to near-death, but all his efforts are futile. He realizes that his goal is not possible either through others or by extreme actions so he decides to rely on his own instincts. Recalling a childhood experience, he resumes meditating under a *bodhi* tree at Bodh Gaya in a final effort to attain enlightenment or awakening. At dawn on his thirty-fifth birthday, he achieves release from the endless round of rebirths and becomes fully enlightened. Henceforth Siddhartha is known as 'the Buddha' or 'Sakyamuni' meaning 'Sage of the Sakya Clan'.

During the last forty-five years of his life, the Buddha walks from village to village on the dusty roads of northern India accompanied by his disciples and followers teaching his message.

> *I will teach. But what I teach is not Buddhism; it is the way to Buddhism,'* said the Buddha. (Joseph Campbell, *Transformations Of Myths Through Time*, pp 111-13)

He becomes seriously ill in his eightieth year and when he reaches the town of Kushinagara he asks his loyal disciple, Ananda, to prepare a bed for him between two trees. The Buddha lies on his right side, draws his last breath and enters *parinirvana*, the final and perfect nirvana.

The disciples of Gotama are always wide awake and watchful, and their thoughts day and night are ever set on the Law. (*Dhammapada*, Chapter XXI, Verse 296 translated from Pali by Irving Babbitt)

The scene of the Buddha flanked by two loyal disciples, Sariputra and Maudgalyayana, is a popular subject in Thai painting, sculpture and the decorative arts. Both disciples were students under the leading teacher of the day. When they met the Buddha, however, his serene presence overwhelmed them and they decided to 'Go Forth' with him.

As the Buddha saw them approach, he said 'here are the two men who will be the foremost among my disciples'. (A. Ferdinand Herold, *The Life of Buddha According to the Legends of Ancient India*, translated by Paul C. Blum).

Ananda, a cousin of the Buddha, was one of the original five disciples whom he converted and in later years Ananda became the Buddha's personal assistant and cared for him until his death.

'O disciples, go...set out on the road, singly and alone. And teach, O Disciples, teach the glorious law, the law glorious in the beginning, the law glorious in the middle, glorious in the end; teach the spirit of the law...' said the Buddha. (A. Ferdinand Herold, *The Life of Buddha According to the Legends of Ancient India*, translated by Paul C. Blum).

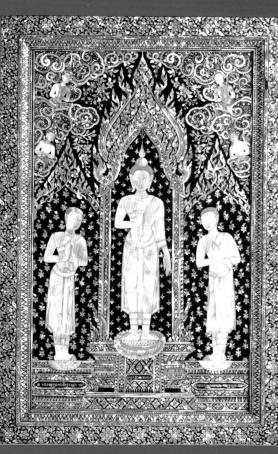

A *stupa* or 'mound' is the earliest symbol commemorating the Buddha as it is where his remains were placed after cremation. The form evolved from a simple earthen burial mound in prehistoric times to an imposing monument for enshrining sacred Buddhist relics and articles of revered religious leaders and royalty. The *stupa* is a colossal brick and stone structure symbolizing the mythical mountain, Meru, situated at the centre of the universe and comprising five fundamental parts – a base, a large dome containing the relics, a platform, a spire and a finial. The name *stupa* is synonymous with *chedi* in Thailand.

The evolution of the Thai *stupa* reflects numerous foreign influences, many of which carry through the centuries. Late thirteenth century Sukhothai artisans combined the bell-shaped dome of Sri Lanka with a graceful spire and lotus-bud finial supported by a square or octagonal base to create what is known today as the classic Thai *stupa*. Sculpted elephants around the base, stairs with serpent balustrades leading to the upper area and moulded rings on the dome were selective additions. Niches with Buddha images around the upper part of the *stupa* reflect Sri Lankan influence via Burma.

The *prang*, a Thai version of the Khmer sanctuary tower, was favoured in the early Ayutthaya period (mid-fourteenth to mid-fifteenth century) and is distinguished by a corncob profile with a trident finial and a porch at the east.

Innovations of the sixteenth and seventeenth centuries were additional terraces and porches, a plethora of angular indentations,

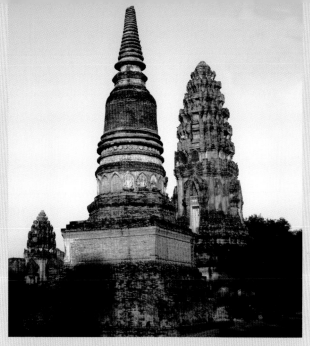

and exaggerated heights achieved by an elevated base and an elongated body. Inlaid coloured glass and enamelled porcelain characterize the *stupa* of the Bangkok period and Chinese-inspired features became increasingly prominent. The whole is a harmonious mélange of foreign influences with indigenous creativity resulting in a towering *stupa* that shimmers in sunlight, glows at sunset and stands today as an icon of a widespread devotion to Theravada Buddhism.

wheel of the law

The Wheel of the Law '*dharmacakra*' is a symbol representing the Buddha's first sermon after he attained enlightenment. Among the most renowned examples of the wheel are large, free-standing stone sculptures made by the Mon-speaking Dvaravati culture, centred around Nakhon Pathom, between the seventh and the eleventh centuries.

A typical Dvaravati wheel comprises a central hole bound by a band of stylized lotus petals with deeply carved spokes radiating from it and a rim with a floral scroll. A flat base provides stability and may be adorned with a figure such as the sun god or the goddess of prosperity. Crouching deer with heads turned as if listening to the Buddha's words often appear at the base of the wheel and recall the Deer Park, at Sarnath, near Varanasi, the location of the Buddha's first sermon. Other examples have a projection at the bottom, giving rise to speculation that the wheel functioned as a capital on a pillar.

The Buddha told his disciples that while meditating under the *bodhi* tree a revelation came to him and showed him a way to eliminate suffering and attain supreme peace. He called it the 'Middle Way', a path between the extremes of material indulgence and profuse austerity. The Four Noble Truths define suffering and its causes and the Noble Eightfold Path describes the steps to follow to eliminate suffering and to attain nirvana.

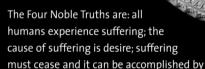

He who takes refuge with Buddha, the Law and the Order; he who with clear understanding sees the four noble truths:- Suffering, the origin of suffering, the destruction of suffering, and the eightfold noble path that leads to the release from suffering –
That is the safe refuge, that is the best refuge; having gone to that refuge, a man is delivered from all suffering. (Dhammapada, Chapter XIV, Verses 190-92, translated from Pali by Irving Babbitt).

The Four Noble Truths are: all humans experience suffering; the cause of suffering is desire; suffering must cease and it can be accomplished by following the Noble Eightfold Path, which consists of Morality (Right Speech, Action and Livelihood); Meditation (Right Effort, Mindfulness and Concentration); and Wisdom (Right Views and Intention). These truths and this path are the fundamentals of Buddhism, as told by the Buddha when he set 'The Wheel of the Law' in motion.

The Buddha's Footprints are a highly revered symbol in Theravada Buddhism and beautifully rendered in Thai art. Based on an impression of the Buddha's footprints in stone, reproductions were made in various materials and styles. The toes of the Buddha's foot are of equal length and incised with finely drawn concentric circles resembling a stylized toe print. A large wheel fills the centre of the sole and the remainder is divided into a grid and the squares are filled with auspicious (often 108) symbols drawing inspiration from Buddhist cosmology and mythology. Small pavilions representing various heavens, for example, mingle with mythical creatures, nature spirits and royal symbols, such as the conch, fly whisk and umbrella. The heels are incised with a trident representing The Three Refuges (The Triple Gems) of Buddhism – the Buddha, the *dharma* and the *Sangha*. The intricate designs on the foot-prints are especially suited to the technique of inlaid mother-of-pearl. Indigenous shell is manipulated to a minuscule thinness and the desired form and applied to wood. The spaces in between are filled with several layers of thick black shellac. This tedious process produces striking results with a pearly-white pattern set in a pitch-black background. A masterpiece of this technique used for the Buddha's footprints can be seen on the reclining Buddha at Wat Pho, Bangkok.

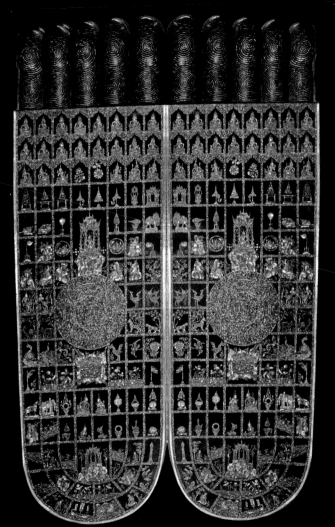

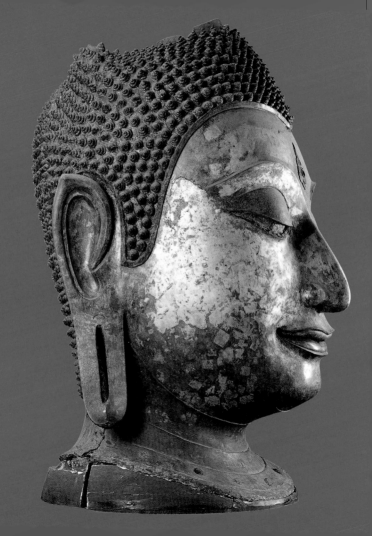

The Buddha was not depicted in human form until around the first century BC, some five hundred years after his death. Images represent the presence of the Buddha and as such are highly sacred objects. Treatises written in India defined the standards of proportions, which were followed in the Buddhist world with minor adaptations by different cultures. Throughout history, Thailand has produced images that transcend reality and capture the Buddha's essence, an idealized beauty that conveys a sublimely spiritual nature.

Early portraits of the Buddha were carved in relief on the walls of *stupa*s; others were freestanding, made of brick and covered with stucco; but the *par excellence* of the form was made in bronze, a material whose casting the Thais fully mastered. The smooth surface and fluidity of line in a bronze Buddha image stand today as hallmarks of Thai art. Characteristics include perfect proportions with smooth and rounded lines; broad shoulders and narrow hips; extended pierced earlobes; stylized hair curls; a protuberance on the head; and an *urna* or round tuft of hair between the eyebrows.

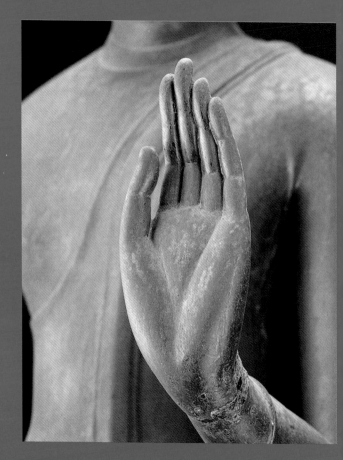

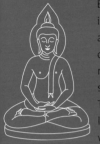

Each image depicts an attitude, episode or a significant time in the Buddha's life, which can be identified by the posture and the hand gesture. The Buddha is commonly shown in one of four basic postures – sitting, standing, walking or reclining – and one of six hand gestures. Sometimes the same gesture is performed with both hands. *Meditation* The future Buddha sits with folded legs (right on top of the left) and hands held together in his lap with palms upward (right on top of the left) This posture and gesture recall Siddhartha's final meditation under the *bodhi* tree before he attained enlightenment.

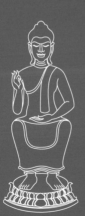

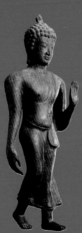

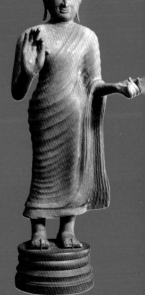

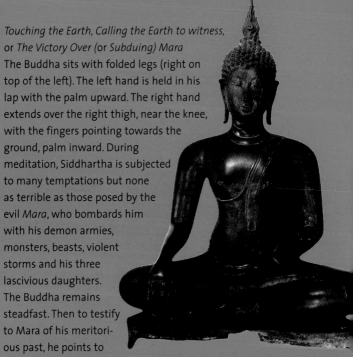

Touching the Earth, Calling the Earth to witness,
or *The Victory Over (or Subduing) Mara*
The Buddha sits with folded legs (right on
top of the left). The left hand is held in his
lap with the palm upward. The right hand
extends over the right thigh, near the knee,
with the fingers pointing towards the
ground, palm inward. During
meditation, Siddhartha is subjected
to many temptations but none
as terrible as those posed by the
evil *Mara*, who bombards him
with his demon armies,
monsters, beasts, violent
storms and his three
lascivious daughters.
The Buddha remains
steadfast. Then to testify
to Mara of his meritori-
ous past, he points to
the earth with his hand and calls forth Thorani, the beautiful earth
goddess. She rises from the ground and wrings the water from her long,
black hair, which raises a torrential flood that drowns Mara and his army
of demons. This episode is often depicted in a mural painting on the east
wall of a main temple building and reminds devotees that good can
triumph over evil (see opposite).

Charity or Bestowing Favours The gesture of charity (either giving or receiving) is seen on standing or seated images. It is made with the right forearm extended and the palm open, facing outward, fingers together and pointing downwards.

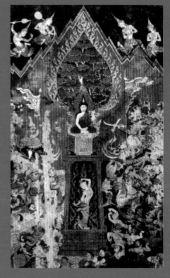

Reassurance or Fearlessness The image is usually standing or walking and executes the gesture by bending either forearm and holding it close to the body with the palm facing outward, fingers together and pointing upwards.

Teaching The teaching gesture is shown on a standing, walking or sitting image with a bent right forearm held close to the body with the palm facing outward, fingers together except the thumb and index finger, which form a circle and touch each other. The left hand of standing images often holds a flap of the Buddha's garment or it may be in the same position as the right hand. It symbolizes the teaching of the Buddha's message.

Turning the Wheel of the Law The image is either sitting in Western fashion or sometimes standing. Both hands are held in front of the chest with palms facing each other and the thumbs and forefingers of each hand joined to form a circle signifying the episode when the Buddha preached his first sermon in Deer Park at Sarnath and se t in motion the Wheel of the Law.

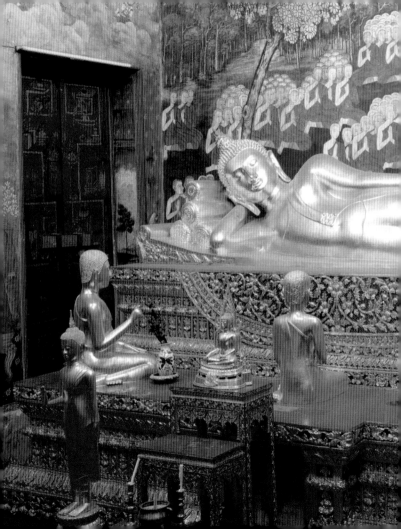

dvaravati

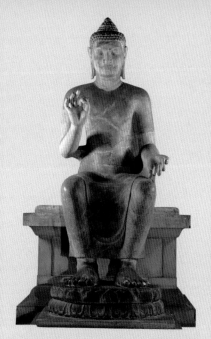

Some of the earliest Buddha images found in Thailand are of the Mon speaking Dvaravati culture, circa seventh century. Mon sculptors worked primarily in stone producing images with distinctive characteristics that are easily identifiable. An overall impression of symmetry, simplicity of workmanship and form define the Mon Buddha image. Whether standing or seated in western fashion, the posture is slightly rigid and always facing forward. Garments cover both shoulders and extend below the

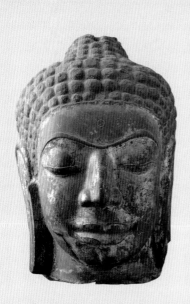

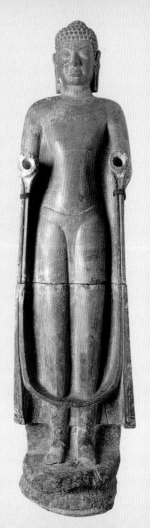

knees in sweeping lines. The teaching gesture, performed with both hands, is typical. The facial features are equally distinctive – a broad full face with eyebrows that form a sharp ridge and join at the bridge of the nose; elongated eyes looking downward and thick lips.

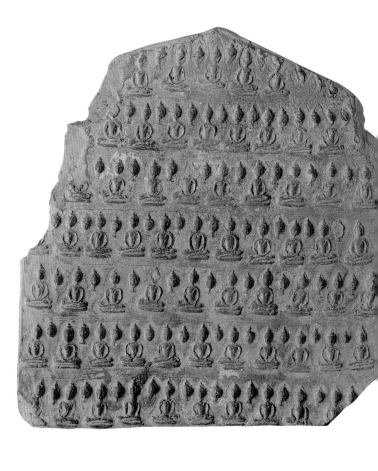

votive tablets

A votive tablet is a miniature Buddhist icon with narrative scenes that has widespread appeal as a talisman from earliest times to the present. Some magnificent ones made of gold, silver, pewter or bronze were found in sacred containers, relic chambers and temple crypts. Above all, a votive tablet is a personal, devotional object.

A typical example is triangular shape, made of terracotta, moulded and either fired in a shallow pit or dried in the sun. A variety of themes draw on the life of the Buddha and cosmology. Portrayals of the Buddha in any one of the four standard postures surrounded by Buddhist emblems are popular. The Buddha meditating under a *bodhi* tree with disciples kneeling on each side is a particular favourite. The Buddhas of the Past, a reference to the many Buddhas before Shakyamuni, is another theme and depicted with horizontal rows of miniature Buddhas seated in meditation in a rhythmical pattern filling the entire surface of the votive tablet. A Buddha room *(hong phra)* in the home with an altar displaying favourite images provides a place where family members can make offerings, say prayers and pursue their individual quest towards nirvana.

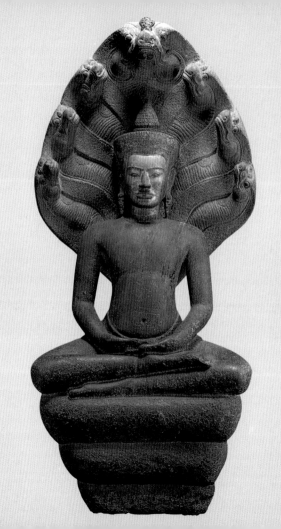

The Khorat Plateau in Northeast Thailand was part of the mighty Khmer Empire between the tenth and the thirteenth centuries. Ruins of stately Hindu and Mahayana Buddhist temples with vibrant carvings are reminders of the cultural influence of Angkor in northwest Cambodia, the centre of the empire, and its extensive territorial control over most of mainland Southeast Asia for some four hundred years. The symbolism of the *naga* or 'semi-divine being' protecting the Buddha was a favourite subject for Khmer sculpture and the legacy was passed on to the Thais where it appears in sculpture and painting. The *naga* has a scaly body with multiple heads and lives in a palatial palace in the murky waters of Mount Meru. As guardian of the waters the *naga* wields considerable power over the prosperity of the kingdom, as harmony on earth cannot exist without abundant water.

According to legend, Siddhartha Gotama was meditating by a lake before he attained nirvana while Muchalinda, the *naga* king was enjoying the pleasures of his subterranean palace when a frightful storm arose. Muchalinda emerged from the waters in a beneficent gesture to protect the Buddha from the storm, coiling his big body to make a seat for the Buddha and lifting him high off the ground. Then he spread his multiple heads and formed a hood over the Buddha for protection.

Theravada Buddhist ideas and Mon artistic concepts spread gradually from the Dvaravati culture in the seventh century northward to central Thailand. By the tenth century, the Mons were forced further north by the Khmers who controlled Northeast Thailand extending to the Sukhothai plain. Meanwhile, Thai-speaking people were migrating into the area and forming small states with independent rulers. In the middle of the thirteenth century, two Thai princes expelled the Khmers and united the small states into one nation, which became the Kingdom of Sukhothai. The acceptance of a strain of Theravada Buddhism from Sri Lanka infused the burgeoning kingdom with dynamism. Its political and territorial power escalated and Sukhothai's control extended to Si Satchanalai in the north, Phitsanulok to the east and Kamphaeng Phet to the southwest.

Sukhothai was a walled city with temples for forest monks in the west, kilns producing high-fired glazed ceramics in the north-west and fertile rice fields in the north. Amidst this setting Sukhothai became a regional centre of religious thought and knowledge. The art flourished and Sukhothai gave birth to a true Thai art style and established aesthetic standards that serve as models for the sacred Buddhist art of Thailand in the twenty-first century.

Alas the kingdom was comparatively short-lived and Sukhothai became a vassal state of Ayutthaya in the south in the late fourteenth century and was annexed a century later.

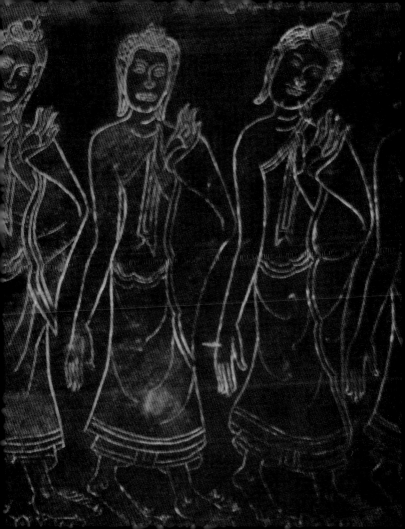

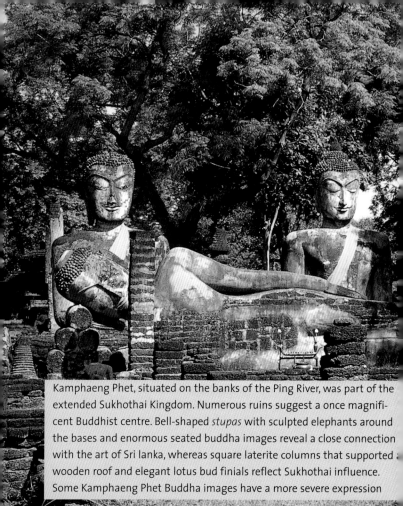

Kamphaeng Phet, situated on the banks of the Ping River, was part of the extended Sukhothai Kingdom. Numerous ruins suggest a once magnificent Buddhist centre. Bell-shaped *stupas* with sculpted elephants around the bases and enormous seated buddha images reveal a close connection with the art of Sri lanka, whereas square laterite columns that supported a wooden roof and elegant lotus bud finials reflect Sukhothai influence. Some Kamphaeng Phet Buddha images have a more severe expression

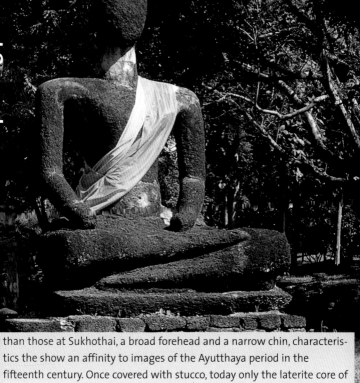

than those at Sukhothai, a broad forehead and a narrow chin, characteristics the show an affinity to images of the Ayutthaya period in the fifteenth century. Once covered with stucco, today only the laterite core of many images remains exposing both the fluidity and the angularity of the original form. A sublime reclining Buddha at Wat Phra Kaeo has graceful curves associated with Sukhothai images and is reminiscent of the renowned rock-cut Buddha at Gal Vihara in Polonnaruva, Sri Lanka.

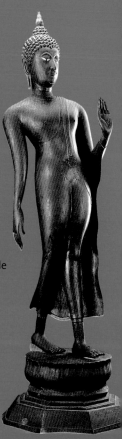

sukhothai walking buddhas

The walking Sukhothai Buddha of the fourteenth century is perhaps the finest achievement in Thai artistic history. The posture of the walking Buddha originated in India but the Thai sculptors took it to an unprecedented aesthetic level and were the innovators of the freestanding form. The walking Buddha performs the teaching gesture with the left hand; the right one rests along the side of the body.

The image has a weightless elegance – a fluid form with subtle movement. The body is lissome and supple, yet the frame is divinely straight. The smooth tapering arms are exceptionally long and extend from broad shoulders.

sukhothai faces

The facial features of the Sukhothai Buddha reflect the Thai concept of an ideal being and reveal an inner spirit. The long, oval face is framed by earlobes that turn outwards slightly at the base. The downcast eyes and gentle smile exude a tranquil expression. The eyebrows form arches over the eyes in an unbroken line.

The shell-like curls of the hair form a heart-shaped line around the face and the flame-like finial rises upward from the middle of the head symbolizing the unsurpassable mental energy of the Buddha.

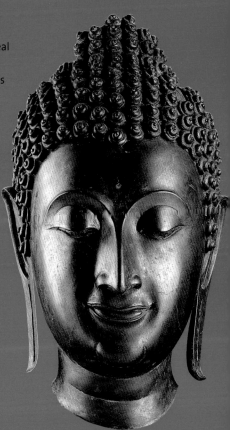

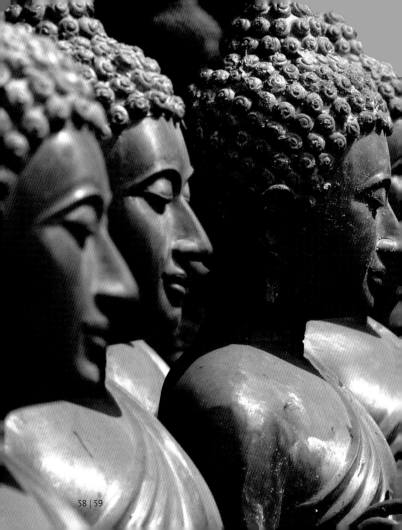

Thai artisans skilfully mastered bronze as a medium for Buddha images using the *cire-perdue* or 'lost-wax' process. A casting session begins with a ritual conducted by a monk to purify the artisans and the mould. Then the head caster makes offerings to exorcise any evil influences and pays homage to his teacher's spirits.

Preparation for casting begins by melting wax over an open fire and preparing a clay mould. The core of the image is made up of layers of clay mixed with broken pottery or rice husks for plasticity. The clay is applied and dried in layers, one by one. Next the wax is poured over the core. Then another layer of clay is added. The mould is fired in a kiln and during firing the wax melts leaving a hollow interior. Meanwhile the bronze (copper, tin, lead) is prepared in large crucibles and then poured into the space vacated by the wax. After cooling the outer layer of clay and the central core are carefully broken away. Finally the bronze sculptors polish the image to achieve a glossy dark brown surface.

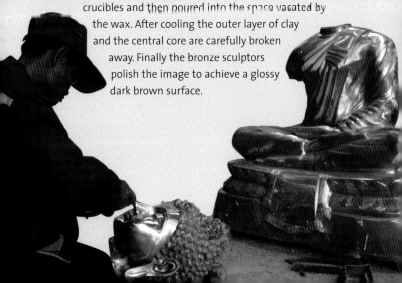

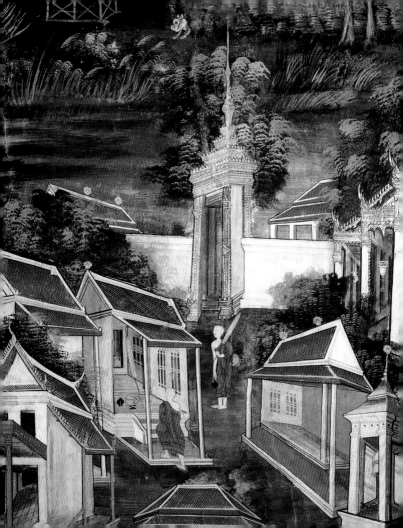

the temple or *wat*

A Thai temple or '*wat*' is a religious centre, a social gathering place and host to ceremonies, festivals and rituals where Buddhists congregate and worship. In the old days, it was also a school. It consists of numerous religious structures surrounded by *stupa*s and enclosed by a wall. The larger temples also have living quarters for the monks. The *naga* motif abounds in a Thai temple. The scaly serpent adorns corners of the roofs of temples to frighten away demons and a pair of *naga*s flank stairways to the *wat*.

Regardless of the size of the temple, there is always an *ubosot*, familiarly called a *bot*, which opens to the east, the direction Siddhartha was facing when he became enlightened. A *bot* is rectangular with a simple exterior and distinctive multiple graduated roofs that are enhanced by a *chofa* meaning 'sky tassel,' which adorns the end of the ridge of each roof. The *chofa* resembles either a stylized serpent or bird and is one of Thailand's most graceful and recognizable architectural features. The interior of the *bot* is elaborately decorated with gilding, black and red lacquer, mother-of-pearl inlay and mural paintings. The primary Buddha image is placed in the centre of the west wall near an altar adorned with candles, flowers and incense. The combination is a profusion of colour, texture and motifs on the interior juxtaposed with a stark exterior.

The *bot*, built on consecrated ground, is the most sacred building and used only for special ceremonies such as the ordination of monks. A *wat* may have one or more *vihara*, which look like a *bot* (both on the exterior and interior) but function as a meeting place for monks and lay people.

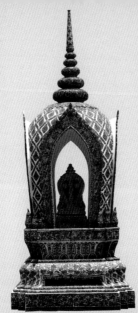

The *bot* or ordination hall is distinguished from other buildings by boundary stones or 'bai sema' placed upright around the exterior of the building. Eight stone slabs – four in the cardinal and four in the sub-cardinal directions – demark the sacred ground of the *bot*. A ninth stone was buried beneath the centre of the building in a ceremony conse-crating the ground before constructionbegan.

A typical boundary stone is shaped like a stylized leaf of the sacred *bodhi* tree, sometimes carved with a figure, such as the Buddha seated in meditation. In modern times, the boundary stones are more elaborate and may be enclosed in a miniature replica of the temple. A double set of boundary stones around a *bot* indicates that the building has been reconstructed.

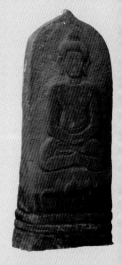

Monumentality and simplicity are artistic features in Sri Lankan art that influenced Sukhothai. A fine example of these aspects is Wat Sichum, (a late fourteenth century temple located outside the city wall), which is the architectural quintessence of the period. A square building with tall walls opening to the sky and a narrow entrance at the east houses a gigantic, yet ethereal Buddha image made of brick and stucco (restored).

It is seated with the right leg on top of the left and the hands are in the gesture of subduing Mara. Only a portion of the Buddha can be seen from the east because of the narrow entrance, which enhances the sense of drama.

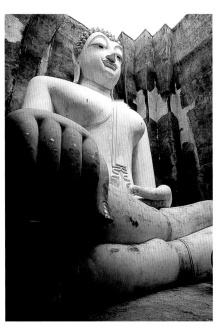

Wat Sichum is renowned for its fine, early slate panels etched with scenes from the *Jataka*s that once lined a narrow stairway but are now in the local museum.

At the same time the Kingdom of Sukhothai was flourishing in central Thailand, another Theravada Buddhist kingdom, Lanna, was established in the north with a capital at Chiang Mai. By 1297, under the leadership of the dynamic King Mengrai, the northern Kingdom of Lanna extended from Chiang Saen in the far north through to Chiang Rai, Chiang Mai, Lamphun (formerly a Mon centre) and Lampang. The Lanna Kingdom lasted from the late thirteenth to the eighteenth century.

The art of Lanna is not as well known as Sukhothai but its style is unique and appealing. And, like Sukhothai, bronze was the favoured medium for Lanna sculptors. An early Lanna image gives the impression of strength and virility. It is seated with legs overlapped in yogic position and the hands are in the gesture of subduing Mara. A narrow waistline offsets an inflated torso and the finial is formed like a lotus or a gem. Large curls and a prominen hairline frame a round, fleshy face. The garment covers the left shoulder with a short flap ending above the left nipple. A base decorated with lotus petals and stamens is typical.

The later Lanna Buddha takes on a slimmer body, has an oval face and the flap of the garment ends above the waistline. Crowned

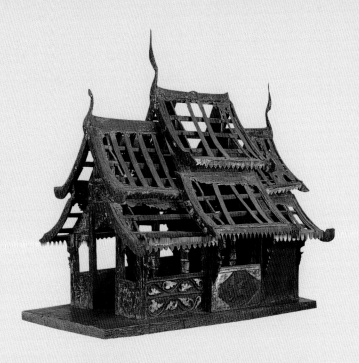

images appeared in royal attire in the Lanna repertoire during the sixteenth century. A unique characteristic in Lanna architecture is a series of superimposed wooden roofs on temple buildings with a sweeping and graceful profile. Lanna mural paintings have an appealing naiveté and freshness. Scenes of the Buddha's life integrated with everyday activities are popular as are the *Jatakas* painted on wood.

ayutthaya

This royal and admirable city is perfectly well situated and populous to a wonder, being frequented by all nations...the city is beautiful with more than three hundred fair temples and cloisters, all curiously built and adorned with many gilded towers and pyramids. (Francois Caron and Joost Schouten, A True Description of the Mighty Kingdoms of Japan and Siam, Facsimile of the 1672 edition).

Ayutthaya (called Siam by early European travellers) became the capital of Thailand in the middle of the fourteenth century and remained the dominant power until 1767 when it was sacked by the Burmese. Ayutthaya is situated in the lower Chao Phraya valley with river access to the Gulf of Thailand. It was a centre for regional trade and a transshipment port on the route between India and China. The architecture drew on previous techniques and influences and gradually resulted in a unique and spectacular style of *stupa* or *chedi* distinguished by a high base and an elongated form tapering to a dramatic point. Early Ayutthaya Buddha images were influenced by the bronze forms of the U-Thong style, which flourished in central Thailand between the twelfth and fifteenth centuries. Facial characteristics recall Khmer features – a square shape with a broad forehead framed by a narrow band, slightly arched eyebrows, downcast eyes and a large mouth. Later, sculpture is characterized by variety of form and style and an increasing tendency towards ornate decoration. Bronze was the favourite material but stone was also used and stucco and brick were the accepted materials for architecture. Gold work, woodcarving and decorative arts were of exceptionally high quality during the Ayutthaya period.

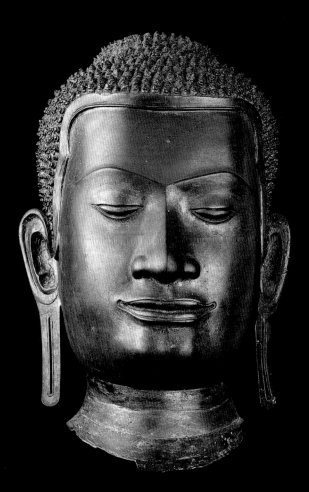

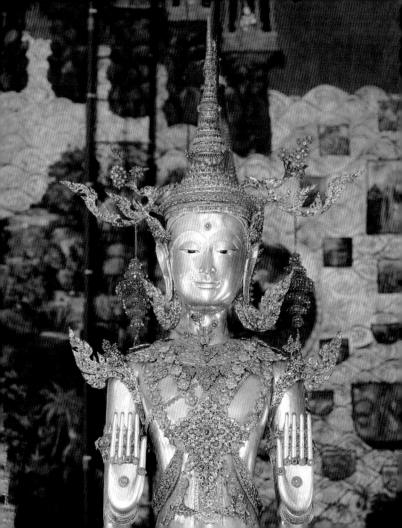

When the Burmese sacked Ayutthaya the royal family fled to Thonburi on the western bank of the Chao Phraya River and in 1782 the capital moved across the river to Bangkok, where it remains today. This was the beginning of the Chakri dynasty and the art style of the Bangkok period which is known as 'Rattanakosin'. Sculpture of the early period follows previous traditions but by the first half of the nineteenth century images in a variety of new attitudes depicting important events in the Buddha's life were made under the direction of the king. A new style of image appeared in the middle of the century that featured standing bronze figures with emphasis on historical accuracy, naturalistic forms and accentuated folds in the garments. This stylistic shift probably occurred because of King Mongkut's scholarly research when he was a monk and the increased foreign influence during his reign. Later sculpture shows a tendency to copy previous styles and an increasing number of heavily adorned crowned images. Chinese influence, ornate decoration and an abundant use of gold leaf appear in architecture and painting of the period.

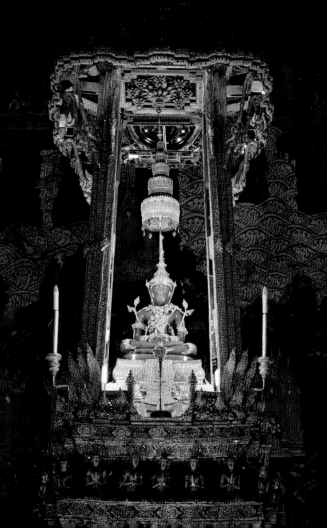

The Emerald Buddha is the most revered image in Thailand. Contrary to popular belief, it is not made of emerald but carved from a solid piece of jade. The Emerald Buddha is housed in Thailand's most sacred building, Wat Phra Si Rattana Sasadaram, familiarly known as Wat Phra Kaeo or the Temple of the Emerald Buddha, built in 1783 in the grounds of the Grand Palace complex. The ethereal image sits meditating with the right leg on top of the left and with hands in his lap, right on top of the left, palms upward. It is relatively small (height 66 cm) but elevated to a high level by a throne made of wood and gilded with graduated tiers. The decoration of the interior of the bot provides a suitably sumptuous background honouring this sacred image. Mural paintings with Buddhist scenes cover the walls, numerous other golden Buddha images are present and icons and emblems proliferate.

The exact date and provenance of the Emerald Buddha are unknown. The earliest mention of this image is 1434 in Chiang Rai, north Thailand. Nearly thirty-five years later, the image was in Chiang Mai, capital of the Lanna kingdom. Some eighty years later, the image travelled to Luang Prabang, Laos as part of a marriage dowry. From there, it was transferred to Vientiane, the present capital of Laos, where it remained for over two hundred years. In 1778, the Thais gained control of Vientiane and brought the image back to the capital in Thonburi and six years later, it was moved to the present location.

phra buddha sihing

The venerated bronze image of Phra Buddha Sihing is the central figure in the Buddhaisawan Chapel in the grounds of the National Museum, Bangkok. The meditating Buddha sits on a lotus petal base with the right leg on top of the left and hands in his lap, right on top of the left, palms upward. A flame-like finial recalls the Sukhothai style.

According to legend, in the fourteenth century two Thai kings learn of a magnificent Buddha image in Sri Lanka and they send an envoy to ask the king for the image as a gift. He agrees to the request and the envoy sets sail for Thailand with the image, but the ship strikes a reef and sinks. The image, though, floats on a plank and reaches south Thailand where it is eventually taken to Sukhothai. Then it becomes an object of booty in wars with the neighbouring northern kingdoms. At the end of the fourteenth century it arrives in Chiang Mai and a temple is built for the revered image. Some two hundred and fifty years later, the King of Ayutthaya seizes the Phra Buddha Sihing and, one hundred years later, the Burmese sack Ayutthaya and take the image back to Chiang Mai. Then, in 1795, Phra Buddha Sihing is taken to Bangkok where it rests today.

The Buddha image leaves the chapel once a year at Songkran (Thai New Year) for the nearby royal grounds where thousands of worshippers sprinkle the image with holy water.

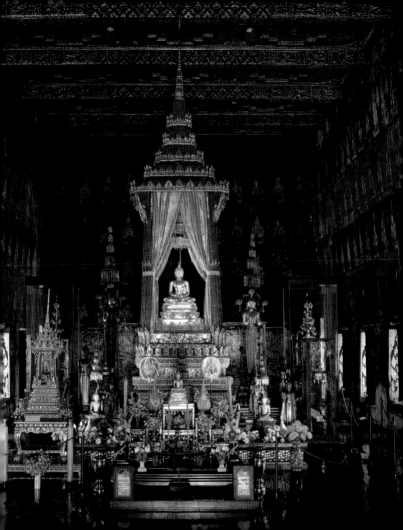

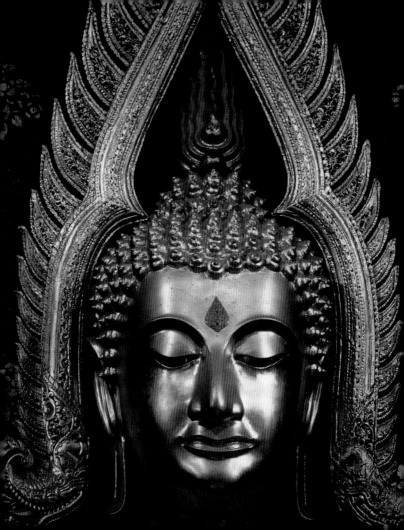

Phra Buddha Chinnaraj in Wat Phra Si Rattana Mahathat, Phitsanulok is considered the most beautiful image in Thailand. The cast bronze gilded Buddha sits on a lotus base with right leg on top of the left and hands in the gesture of subduing Mara. An elegant golden frame of stylized leaves that terminates in a mythical creature on each side emphasizes the graceful profile of the image.

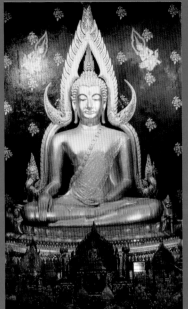

According to a nineteenth century legend, the Thai king who founded Phitsanulok engaged craftsmen from several regions to cast bronze Buddha images for the numerous religious structures. They made wax models but did not have enough bronze to cast the Chinnaraj Buddha. The god Indra descended from heaven and the image was successfully cast soon after.

ordination

The ordination of a young man is one of great religious significance for the entire family and it is also an occasion for merit making and boisterous celebration. The candidate will have to learn with a teacher the fundamentals of Buddhist life. The candidate's parents host preparatory festivities for his ordination, which may take place for days before the event.

On the day of the ceremony, the candidate is transported from his home to the temple, either by riding on the shoulders of friends or in decorated transport, such as the back of an elephant. It is a joyous procession accompanied by dancing, an orchestra of drums and villagers carrying food for the monks, flowers, incense, candles and numerous umbrellas adorned with strands of fresh tropical flowers. Upon arrival at the ordination hall, the candidate asks to be admitted to the *Sangha*. Having been well prepared by his teacher he receives full ordination and a Pali name. Monks chant a blessing and the ceremony ends.

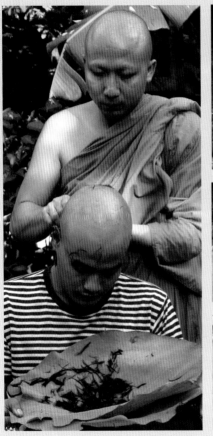
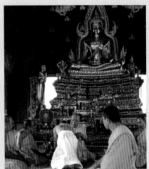
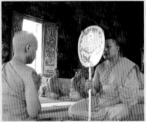
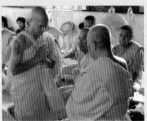

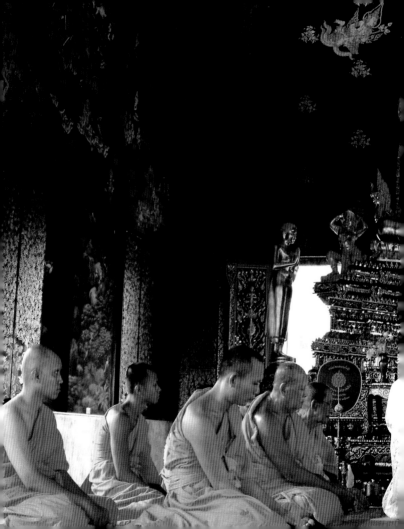

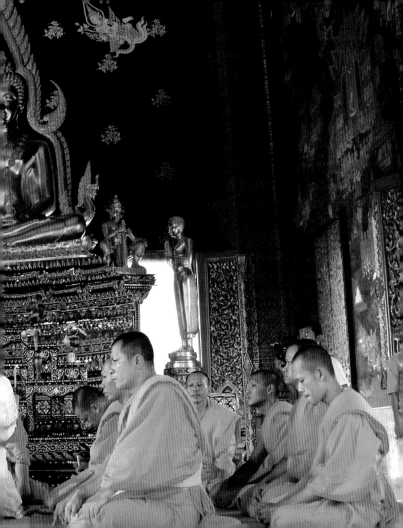

Religious festivals centre on the lunar calendar. Taking place throughout the year on the night of the full moon they commemorate an important event in the Buddha's life. Villagers and families gather at the temple to pay their respects to the Buddha and his teachings. Major festivals symbolize the 'Triple Gem' (the Buddha, his teaching or *dhamma*, and the order of the monkhood or the *Sangha*).

> To the Buddha I go for refuge;
>
> to the Dhamma I go for refuge;
>
> to the Sangha I go for refuge
>
> (Gerald Roscoe, *The Triple Gem, An Introduction to Buddhism*)

Because of the importance of the Triple Gem, the number three has a special significance in these festivals. Devotees bow in obeisance three times before the image of the Buddha and they bring three items (a flower, a lighted candle and a burning stick of incense) as offerings. They circle the *ubosot* three times in a clockwise direction symbolizing the endless cycle of life.

Maka Bucha is celebrated in February or early March and recalls the gathering of 1,250 disciples who were

ordained by the Buddha. It commemorates a major sermon by the Buddha, which was on the rules of the *Sangha*.

Visaka Bucha takes place in late May or early June in honour of the three major events in the Buddha's life – his birth, enlightenment and death. Devotees offer food to the monks in the morning and an important sermon is delivered in the evening.

Asalaha Bucha is held in late July or early August and marks the anniversary of the Buddha's first sermon after his enlightenment delivered in the Deer Park at Sarnath.

Khao Pansa marks the beginning of Buddhist Lent, between July and October. It is a period when the monks study and teach. It also recalls the time when the Buddha went to Tavatimsa Heaven to preach to his mother. At the begin

ning of *Khao Pansa*, devotees present the monks with necessary items – food and garments – for the three months of retreat.

Thot Kathin, the 'laying down robes' ceremony, is held between October and November and is an important way of gaining merit and an opportunity to give thanks to the monks who spread the teachings of the Buddha during the rainy period.

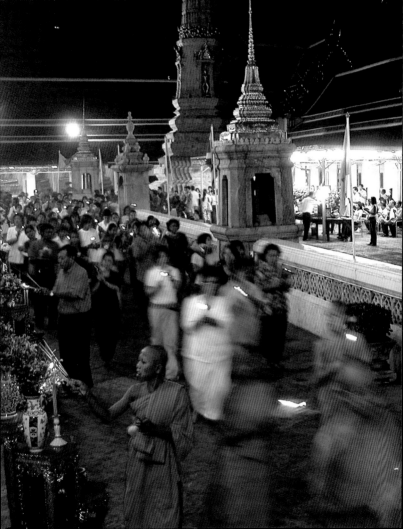

An annual royal Kathin ceremony was initiated by the first king of the Chakri Dynasty in 1782 following Ayutthaya tradition. He named the barge Suphannahongse (*hamsa*) or 'floating golden swan'. The internationally renowned Royal Barge Procession continues today in a grand annual river procession with a flotilla of bedecked barges and uniformed rowers plying the Chao Phraya River to Wat Arun or 'The Temple of the Dawn' on the west bank where the king presents new robes to monks at the end of the three-month Lenten period. The Suphannahongse is made from the trunk of a single teak tree and the prow looks like a mythical creature with bulging eyes, a tassel dangling from its mouth and a garland with pendant around its neck. The king sits in the middle on an elevated golden throne sheltered from the sun by a tiered umbrella. The golden barge inlaid with glass, is a dazzling sight as it glides along the river.

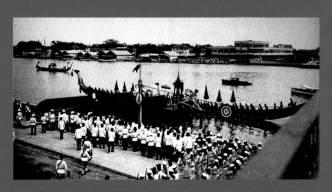

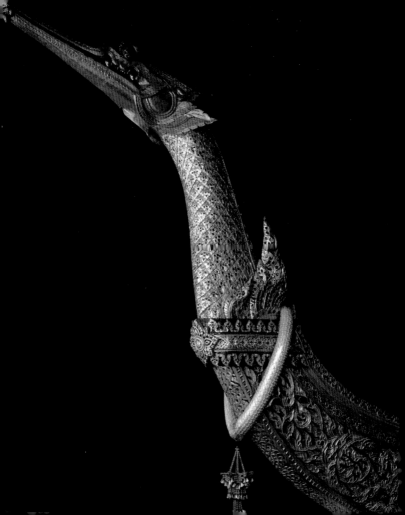

Only eight items are necessary for life as a monk.....

robes, three in all, the bowl for alms,

the razor, needle, and the belt,

and water-strainer, - just these eight

are needed by th'ecstatic monk.

(Buddhism in Translations, Henry Clarke Warren trans., 1969, p 67).

Alms Bowl (Batra) Monks receive food from donors daily in an alms bowl. Materials vary from a simple one of pounded iron with a brass rim and rounded base to one inlaid with mother-of-pearl, which is for the exclusive use of senior monks. The pedestal and the cover are intricately decorated with a delicate floral and scroll design.

Tray (Khaan) Monks' trays are made in a variety of styles and materials, depending on the function. Like the alms bowl, inlaid mother-of-pearl is a particular favourite for royal trays. A round pedestal tray made of wood, lacquer, metal or ceramic filled with incense, candles, flowers and, often, betel serves as an offering tray to the TripleGems. Another type of tray is used to present robes to monks. Yet another has cone-shaped cover and transports dishes for presenting alms or offerings to monks.

Fan (Talapatra) A monk traditionally holds a fan in front of his face while chanting

or meditating. The most common type is oval in shape, flat and mounted on a staff. Some of the cloth-covered fans are sumptuously decorated with royal seals, embroidered with Buddhist sayings or auspicious symbols.

Robe (Chivorn) The guidelines for garments worn by monks today were presumably set out by the Buddha and have undergone minor local modifications based on climate. The basic monk's garment consists of three rectangular pieces of saffron-coloured cotton cloth – an under garment, a robe and a shawl. The method of draping the pieces varies slightly but the transparency of the Buddha's garment is always kept in mind. It is multi-purpose and can be draped over both shoulders or only the left one, depending on the function.

Bag (Yam) When going outside the temple a monk carries a shoulder bag made of the same type of cotton cloth as the robes. It is open and used for carrying necessary utensils. Like the fan, the decoration on the bag varies from simple to complex.

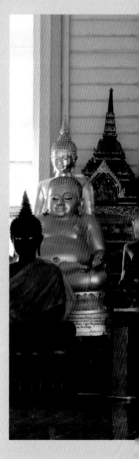

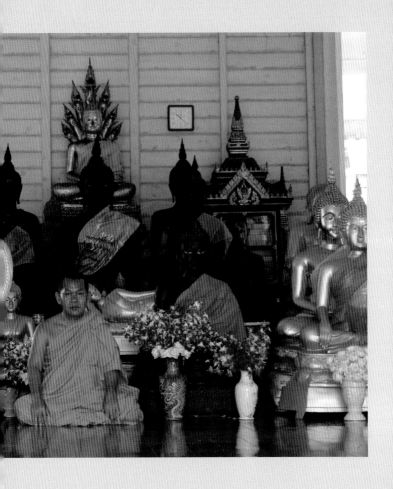

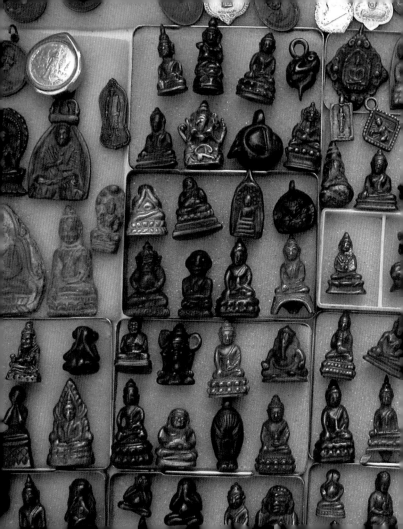

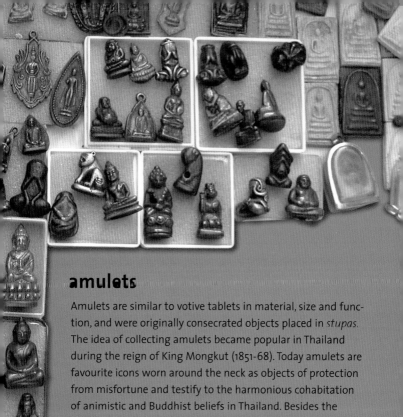

amulets

Amulets are similar to votive tablets in material, size and function, and were originally consecrated objects placed in *stupas*. The idea of collecting amulets became popular in Thailand during the reign of King Mongkut (1851-68). Today amulets are favourite icons worn around the neck as objects of protection from misfortune and testify to the harmonious cohabitation of animistic and Buddhist beliefs in Thailand. Besides the Buddha, images of kings or gifted monks are also made. An amulet blessed by a renowned monk, especially a forest dweller, is particularly auspicious as some are believed to have the power to manipulate spirits.

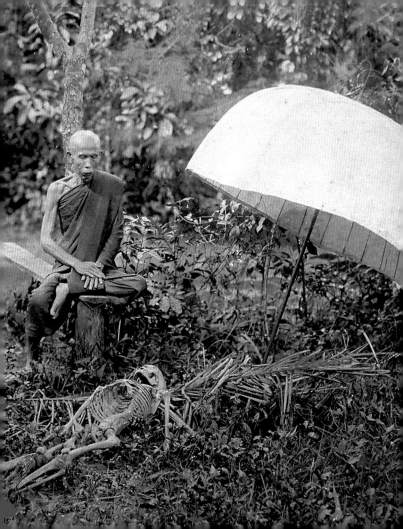

He who, unwearied, sits alone, sleeps alone, and walks alone,
who, alone, subdues himself, will find delight in the outskirts of the forest'.
(Dhammapada, Chapter XXI, Verse 305)

The Aranyika sect of monks lives in forests or caves and its members seek solitude for meditation. Forest monks are highly regarded by Buddhist worshippers and some people think they have supernatural powers, can cure illnesses or can predict the future.

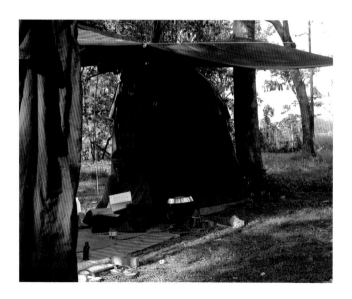

From the time Siddhartha left the palace to become an ascetic in the forest, his life was inseparable from nature. At the moment of his awakening twenty-five hundred years ago he was sitting under the *bodhi* tree, lotus blossoms fell from the heavens, the sky turned a radiant gold and joy spread throughout the universe.

A sapling from the original *bodhi* or pipal tree *(ficus religiosa* in Latin) was taken to Sri Lanka around the second centruy BC where it still thrives and is the oldest known tree in the world. Today the sacred *bodhi* tree is a universal symbol of enlightenment and peace.

The lotus rises from the muddy waters and its eight petals unfold as white and pure as the Buddha's message. The Buddha is often depicted standing or sitting on a lotus base and the revered flower is used abundantly in sacred painting.

'...throughout the ten thousand worlds the flowering trees bloomed;

...trunk-lotuses bloomed on the trunks of trees; branch-lotuses on the brandches of trees; vine-lotuses on the vines; hanging-lotuses in the sky;

...and stalk-lotuses burst through the rocks and came up by sevens'.
(Buddhism in Translations, Henry Clarke Warren, 1969, P82).

Light is everywhere in the universe in various shades and intensities. Walking to Varanasi, the Buddha said, *'and there I shall light the lamp that will bring light into the world, a light that will dazzle even the eyes of the blind.'* (A. Ferdinand Herold, *The life of Buddha According to the Legends of Ancient India).*

Candles symbolize the Buddhist doctrine and his presence. In a ceremonial gesture, devotees light a candle at the beginning of the Buddhist Lent and it remains lit twenty-four hours a day throughout the three-month period. At all religious festivals, lighting the first candle at the temple is a great honour, a privilege usually reserved for the chief monk, the royal family or an important member of the community. A humble offering at a Buddhist temple is an orange candle combined with flowers and three sticks of sandalwood, which, collectively represent the 'Three Gems' of Buddhism – the Buddha, the *dharma* and the *Sangha.*

From all that we love, we must one day be separated.

Captions

Front cover *Hand of the Buddha in the teaching gesture; a Wheel of the Law on the palm, bronze, (NM Bangkok)*

Back cover *Reclining Buddha on a pedestal, wood, lacquer, gold leaf, Rattanakosin style, c. 19th-20th C, (NM Bangkok)*

02 *Face of the Buddha, bronze, Sukhothai style, c. 15th C, (NM Bangkok)*

03 *Votive tablet, the Buddha sitting (western fashion) surrounded by miniature stupas, terracotta, Dvaravati style, c. 8th C, (NM Ratchaburi)*

04 *Mural painting, Suparaka Jataka (detail), c. 19th C, (Wat Khruawan, Bangkok)*

06 *Cloth banner, the bodhisattva receives boiled rice from Sujata and ends his fast (detail), c. 19th C, National Gallery, Bangkok*

07 *Relief carving, bodhi tree, sandstone, Dvaravati style, c. 8th-9th C, (NM Bangkok)*

09 *Map, South and Southeast Asia by Pierre du Val, 1677 (detail), (Private collection)*

10 *Portable table for holding a Buddhist manuscript, teakwood and ivory, (Wat Pho, Bangkok)*

11 *Palm leaf manuscript, Tripitika text with black and gold lacquer cover (detail), c. 19th C, (Wat Pho, Bangkok)*

12 *Mural painting, Thai Buddhist cosmological detail of heavens, mountains and oceans in the universe, 19th C, (Wat Suwannaram, Thonburi)*

14 *Cloth banner, the last ten Jatakas, c. 19th C, (NM Bangkok)*

15 *Standing Buddha surrounded by the only complete set of 547 Jatakas (detail), c. 19th C, (Wat Khruawan, Bangkok)*

16-17 *Mural painting, guardian of the oceans rescues the 'Lost Prince' from a shipwreck, Mahajanaka Jataka (detail), c. 19th C, (Wat Khruawan, Bangkok)*

18-19 *Cloth banner, Vessantara Jataka (detail), (Wat Palilay), c. 19th C, Surat Thani.* **(18)** *Maddi and w beasts in the forest.* **(19)** *The family walks to the hermitage after giving away their possessions*

20 *(top);* **21** *(bottom) Folding manuscript, the story of Malai, the monk who flew to heaven and met the fu Buddha, c. 19th C, (Wat Pho, Bangkok)*

21 *(top) Folding book manuscript, yellow on a black background, c. 19th C, (Wat Pho, Bangkok)*

22 *Scripture cabinet, the Buddha descending from Tavatimsa Heaven (detail), black and gold lacquer, 18t (Wat Hong Rattanaram, Thonburi)*

23 *Scripture cabinet, Prince Siddhartha leaving the pa with his horse and groom, mother-of-pearl inlay, c. 18 (Royal Collection of Ho Phra That Montien)*

24 *Poster; birth of the Buddha, modern*

25 *Relief carving, birth of the Buddha, found at Prasa Phimai, c. 11th-12th C, (NM Bangkok)*

27 *Scripture cabinet (detail, see page 23), mother-of-p inlay, (Royal Collection of Ho Phra That Montien)*

28 *Postcard, the serpent, Muchalinda, protecting Siddhartha Gotama (while meditating) during a stor. modern, (Private collection)*

29 *Miniature cabinet, reclining Buddha on a pedestal surrounded by a tree, wood, lacquer, gold leaf, Rattanakosin style, c. 19th-20th C, (NM Bangkok)*

30-31 *The Buddha standing between two disciples, Rattanakosin style, c. 19th-20th C, (Nat. Gall., Bangkok* **(30)** *Cloth banner, (Nat. Gall., Bangkok)* **(31)** *Screen, mother-of-pearl inlay, (NM Bangkok)*

33 *(forefront) Bell-shaped stupa; (background) cornco shaped stupa, brick and stucco, 12th century temple reconstructed in Ayutthaya period, late 17th C, (Wat Phra Si Rattana Mahathat, Lop Buri)*

Text Credits

26 The Dhammapada, Irving Babbitt, trans., Chapter Verse 43, New York, New Directions, 1965.

29 The Dhammapada, Chapter VII, Verse 99.

29 Joseph Campbell, Transformations of Myths Thro Time, New York, Pantheon Books, 1964, pp 111-113.

30 The Dhammapada, Chapter XXI, Verse 296.

30 A. Ferdinand Herold, The Life of Buddha Accordin the Legends of Ancient India, Paul C. Blum, trans., To Charles E. Tuttle, 1954, p. 176.

30 Herold, p. 128.

35 The Dhammapada, Chapter XIV, Verses 190-92.

56 Herold, p. 176.

66 Francois Caron and Joost Schouten, A True Descri of the Mighty Kingdoms of Japan and Siam, Facsim the 1672 edition, The Siam Society, Bangkok, 1986, p.

80 Gerald Roscoe, The Triple Gem, An Introduction t Buddhism, Bangkok, Silkworm Books, 1994, p. 8.

87 Buddhism in Translations, Henry Clarke Warren, t New York, Atheneum, 1969, p. 67.

93 The Dhammapada, Chapter XXI, Verse 305.

94-95 Warren, trans., 1969, p. 82.

95 Herold, p. 116.

First published and distributed by
River Books Co., Ltd.
396 Maharaj Road, Tatien, Bangkok 10200
Tel. 66 2 622-1900, 224-6686, 222-1290
Fax. 66 2 225-3861
E-mail: riverps@ksc.th.com
www.riverbooksbk.com

A River Books Production.
Copyright © collective work: River Books, 2003
Copyright © text: Dawn F. Rooney, 2003
Copyright © photographs: River Books, 2003

British Library Cataloguing-in Publication Data.
A catalogue record for this book is available from
the British Library.

ISBN 974 8225 75 5

Editor: Narisa Chakrabongse
Design: Paisarn Piemmattawat & Suparat Sudcharoen
Production & photographs: Paisarn Piemmattawat

Printed and bound in Thailand by
Amarin Printing and Publishing Co., Ltd.